RUDE LONDON

First published in the United Kingdom in 2012 by
Portico Books
10 Southcombe Street
London
W14 0RA

An imprint of Anova Books Company Ltd

ISBN 9781907554452

A CIP catalogue record for this book is available from the British Library.

10 9 8 7 6 5 4 3 2 1

Printed and Bound by 1010 Printing International Ltd, China.

This book can be ordered direct from the publisher at
www.anovabooks.com

To see more images of London looking tired and emotional, please visit www.shitlondon.co.uk

RUDE LONDON

SNAPSHOTS OF A CITY WITH ITS PANTS DOWN

PATRICK DALTON

PORTICO

London, that great cesspool into which all the loungers and dirty buggers of the Empire are irresistibly drained.

Sir Arthur Conan Doyle

INTRODUCTION

Smut, innuendo and double entendres are such a massive part of British society that were they to disappear overnight gaping holes would appear in our conversations, our humour and our lives. I'm pretty sure that a percentage of you that read the last sentence might have sniggered at my use of the words 'gaping holes' and if you didn't then you almost certainly have now. This is entirely my point. It is perhaps a national trait of ours that we should be more proud of having produced some of the finest minds and humorists the world has ever known while also retaining a base sense of humour that stopped developing sometime around primary school. It traverses our class system, is appreciated by all ages and can be found everywhere.

London, as many people from outside the M25 will tell you, is nothing more then a filthy crime-ridden den of depravity and moral decrepitude with perverts lurking on every corner looking for their next sordid thrill. The riots of August 2011 showed just how volatile the city can be, how the thin veneer of civilisation can slip and bubble over into anger and wanton violence. From the ashes of that August, Londoners came together and proved that the city was also capable of great love and respect. Of course none of that is contained within these pages. What you'll find here is the kind of sick, filthy, sexy love that exists scribbled in the seediest corners of this city. Total, apolitical, juvenile smut. The kind we're comfortable with. The good stuff.

The city has a plethora of innuendo-laden or plain dirty street names that feature in this book. Whilst out hunting for photos I tried to find a small alley near Smithfield Meat Market with the proctological sounding name 'Back Passage'. I'd found it in an A to Z and consulted a Google map but for the life of me couldn't find it when I actually got there. I was certain I was in the right place but just couldn't see the sign. Giving up and doubting my own orienteering skills I decided to consult the closet thing to an oracle, the landlord of the nearest pub. I walked up to the bar

and announced 'I'm looking for Back Passage' which probably wasn't the best idea. Thankfully he knew exactly what I was talking about and told me that the sign had been stolen so many times that the City of London Authority had decided it would be cheaper and easier just to leave the alley unmarked. This I thought a shame but it reminded me of another street name that had been consigned to the historical dustbin for the sake of taste and decency. In a far more prosaic age when people named London streets after the professions that were found there, there used to be a place called 'Gropecunt Lane'. I'll leave it to your imagination what went on down there.

The photos in this book have been captured by myself and other Londoners in their travels around the city. There is an astounding amount of this strange ephemera out there should you choose to see it. Almost every newsagent window, every pub toilet holds a dirty little secret of its own. Even in the shadow of Parliament there is some smutty stuff going on. It is a major regret of mine that we can't print this photo in a large size (the picture below was taken on a crap camera phone) but let me tell you about it anyway. At a certain of year, at a certain time of day and if the sun is at the correct angle, the light streaming through the ironwork on Westminster Bridge creates silhouettes that look just like a schoolboy drawing of a cock and balls. I tried to get the shot on my SLR and hung around Westminster Bridge trying to work out exactly when this trick of light would happen, but alas to no avail. My hanging about in such a sensitive area for so long inevitably attracted the attention of the police and I was briefly questioned under the Prevention of Terrorism Act. You can imagine how well it went when I explained what I was doing, 'So, sir, you're seriously telling me that you're waiting here with your camera until some penis-shapes magically appear on the bridge, are you?'

It's a dirty job I know, but someone's got to do it.

Westminster Bridge Knobs

Patrick Dalton
London, September 2011

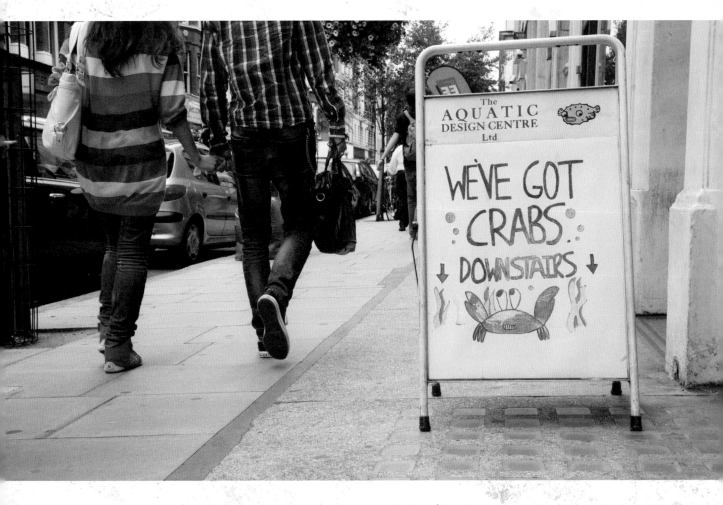

The
AQUATIC
DESIGN CENTRE
Ltd

WE'VE GOT
CRABS
↓ DOWNSTAIRS ↓

Pubic Lice/Sea Crustacean Pun, Great Portland Street

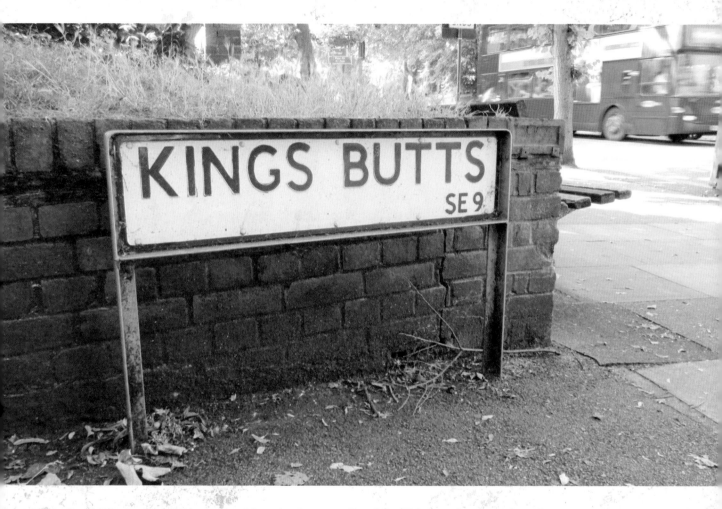

Historically the home of the monarch's prized arse collection, Eltham

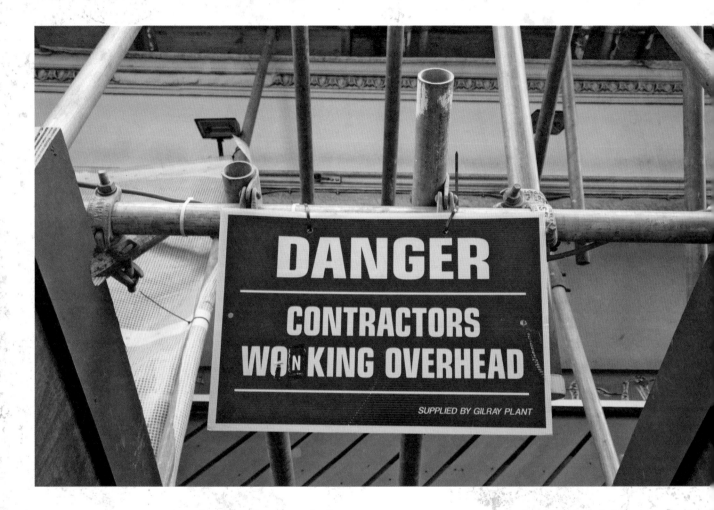

Don't look up!, Kings Cross

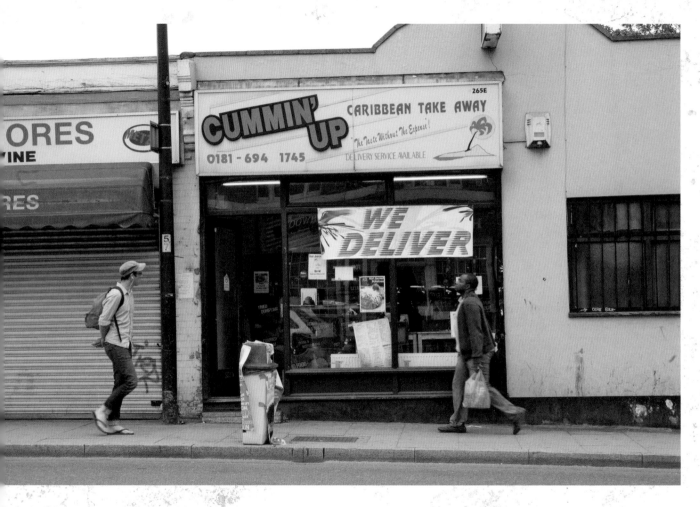

'We deliver' has never sounded so ominous, New Cross Gate

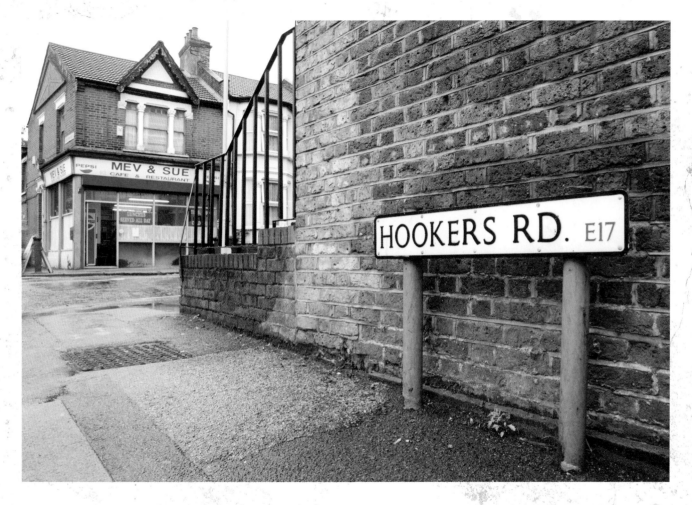

Lock your doors, Waltham

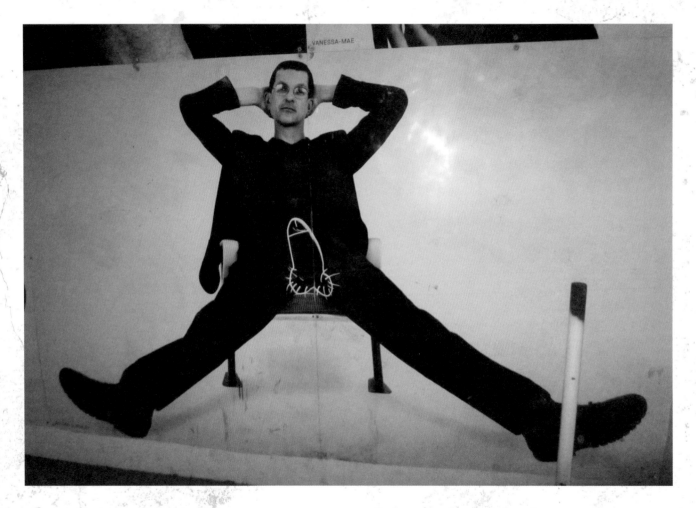

Anthony Gormley's proud erection, Festival Walk

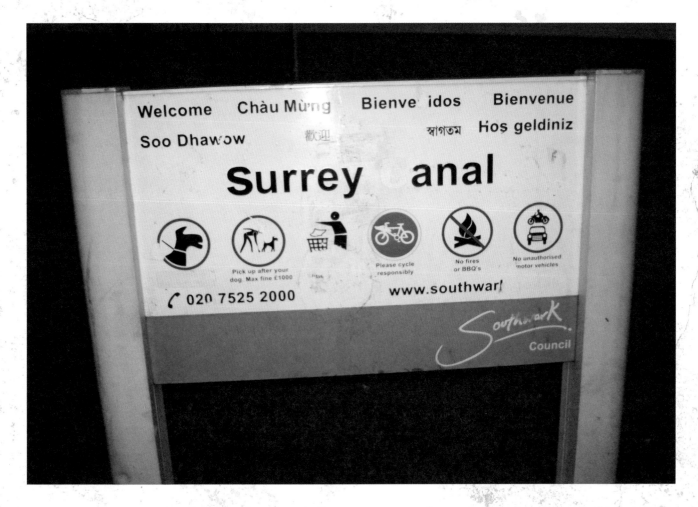

Surrey outsources its anal work to Southwark, Burgess Park

Knob kiss, Tottenham Court Road

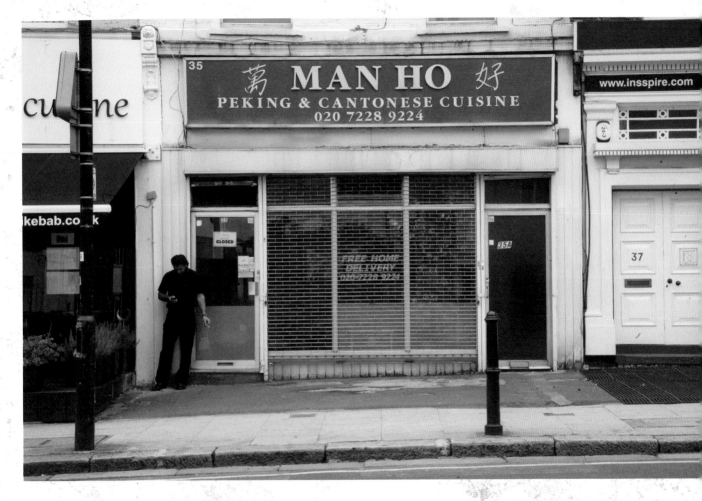

Don't ask for the cream of Sum Yung Gai, Lavender Hill

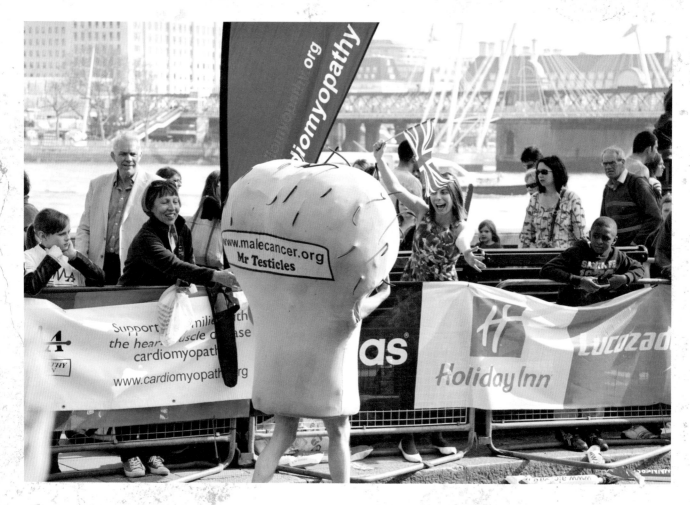

Joy from the adults, fear and confusion from the children, Embankment

Open since 1975, Chelsea

Inflatable wife, Newham

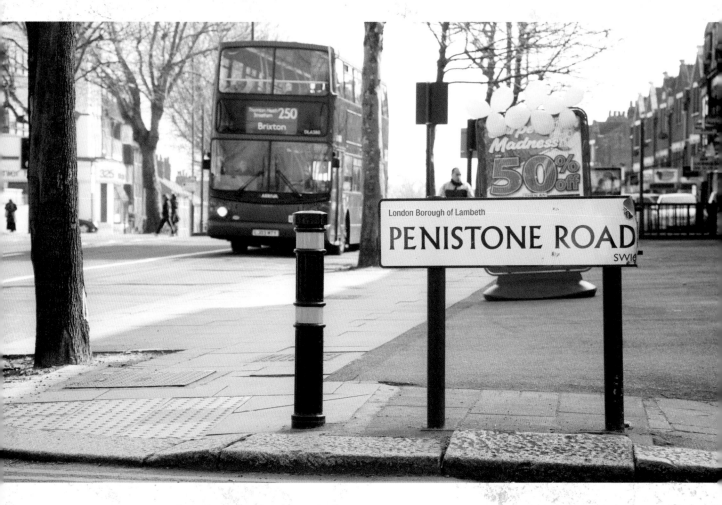

Pronounced as two words, Penis Tone (obviously), Streatham

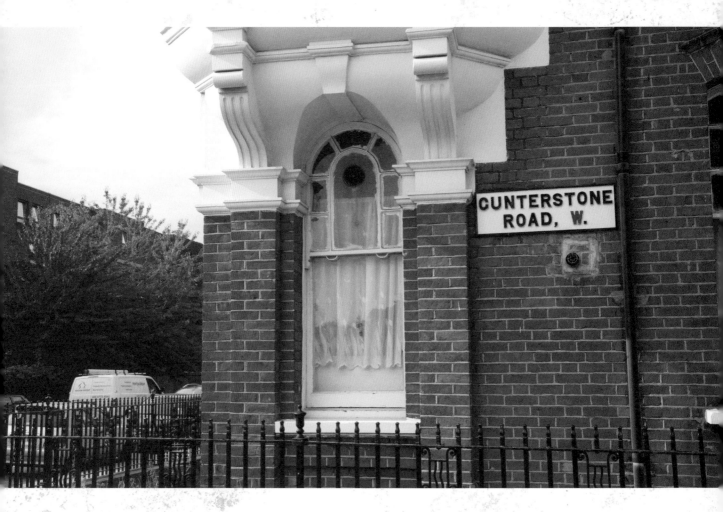

Hard as rock, Hammersmith

Two up, one down, Barnet

Grabby graffiti, New Malden

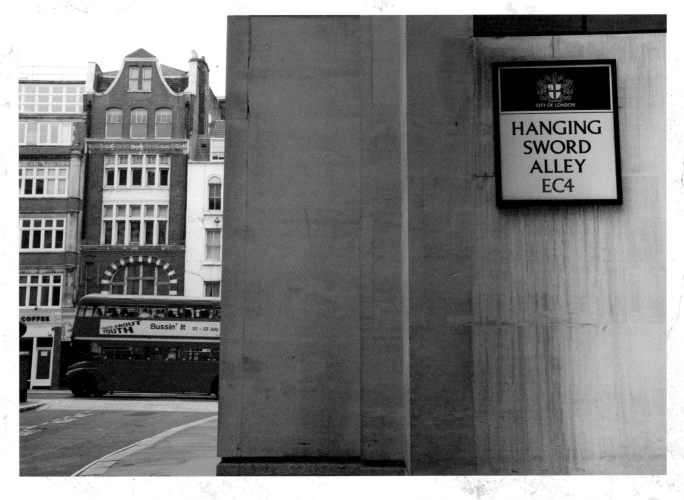

The first cut is the deepest, City of London

Nevermind ..., Aldgate East

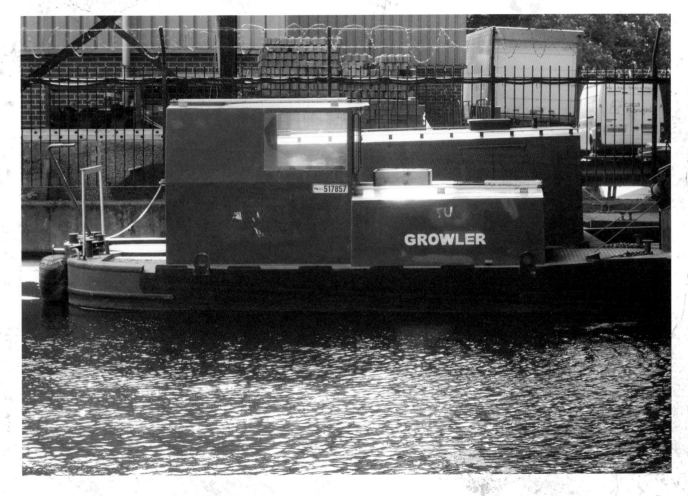

Tug boat growler, River Lea

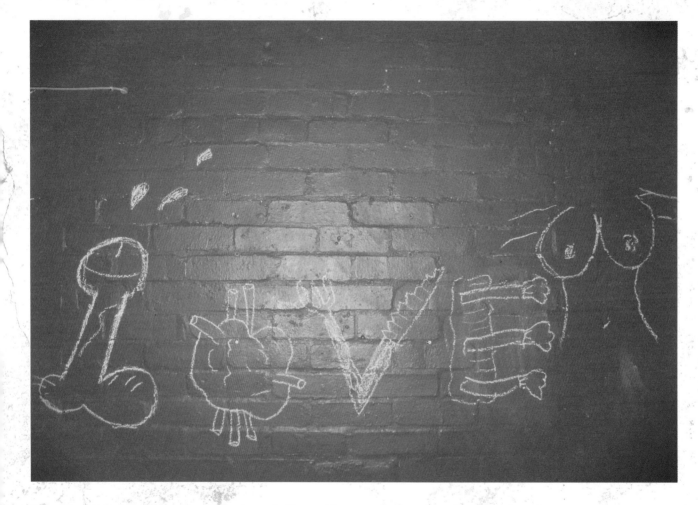

'Love' rendered in knobs, boobs and meat, Manor House

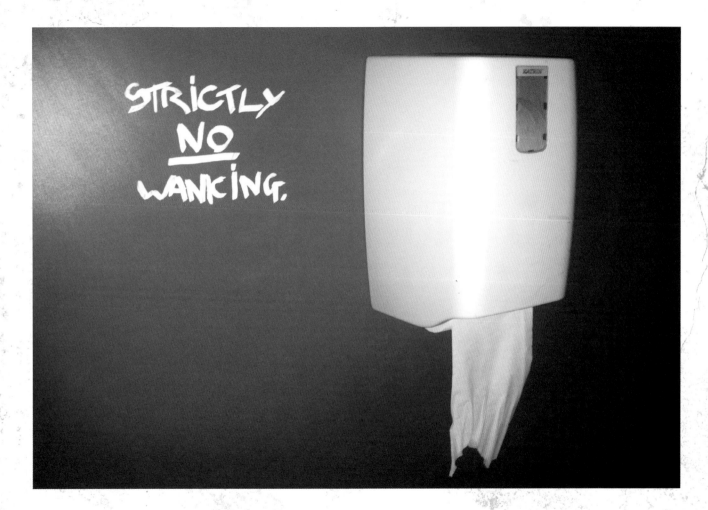

Gents Toilet, Curzon Cinema Soho

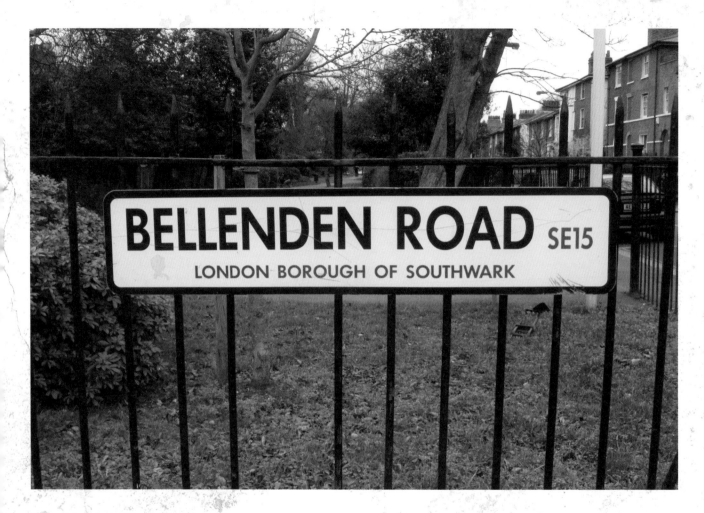

Populated by pricks?, Peckham

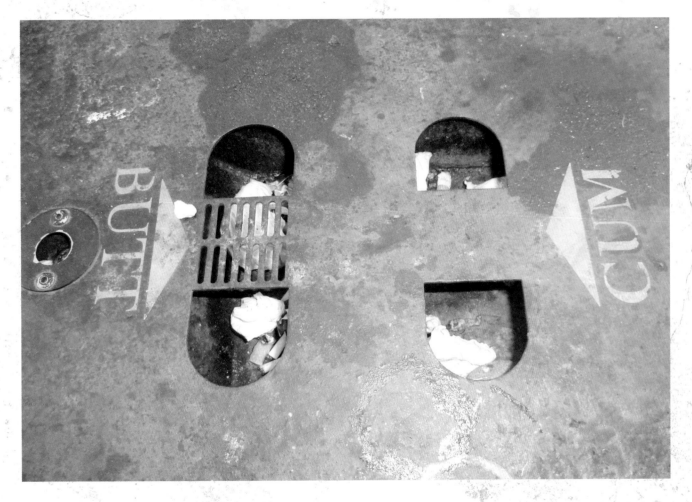

Keep Britain Tidy, Brixton

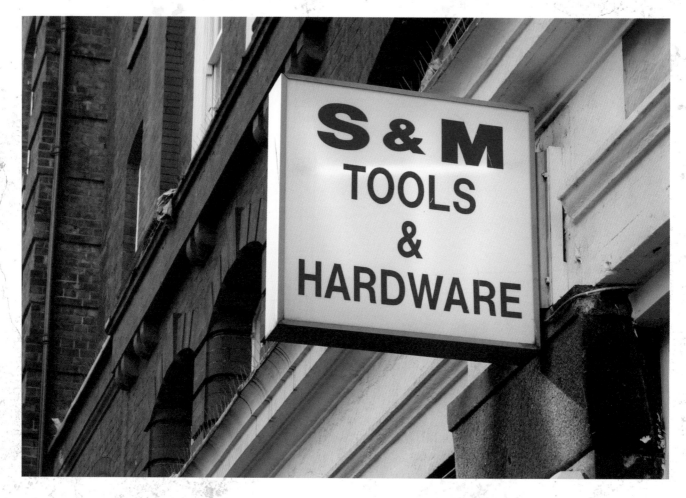

For all your sadomasochistic needs, Leather Lane

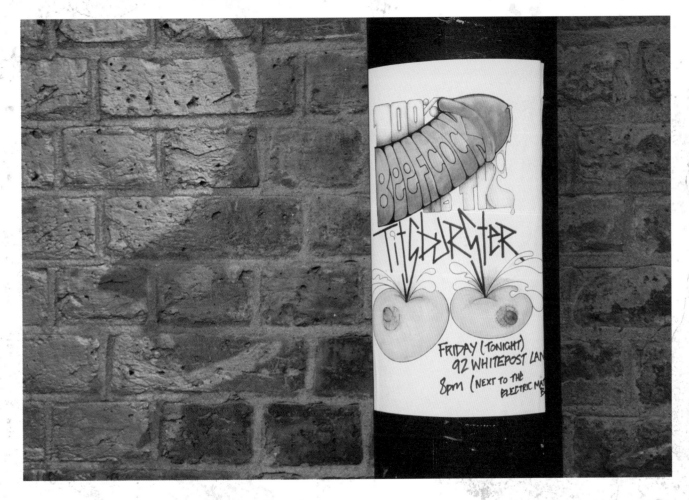

The best band name ever?, Hackney Wick

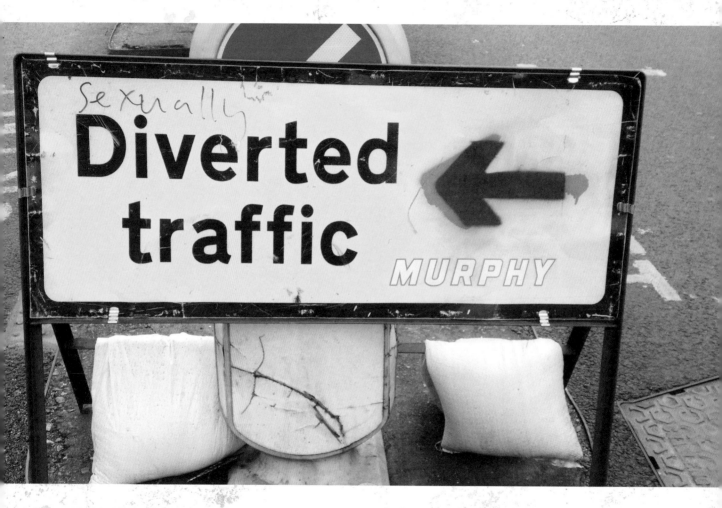

Adapted sign, Dalston

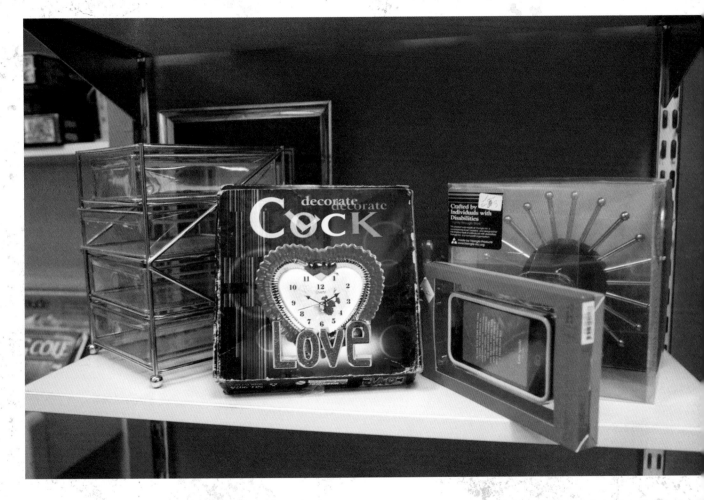

Terrible product design, Help the Aged, Leather Lane

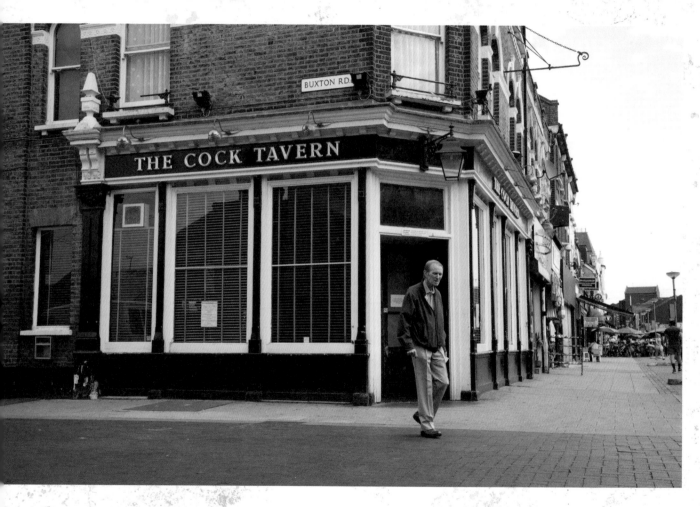

Strange punters, Walthamstow

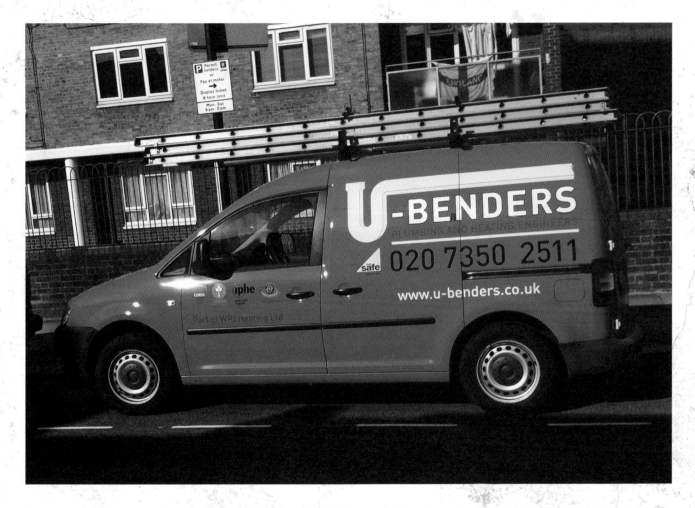

Walking the tightrope between genius and homophobia, Parsons Green

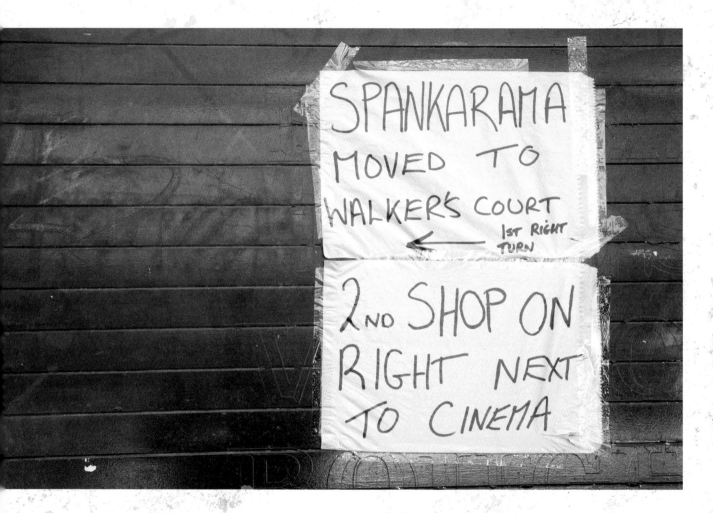

Moving notice, Soho

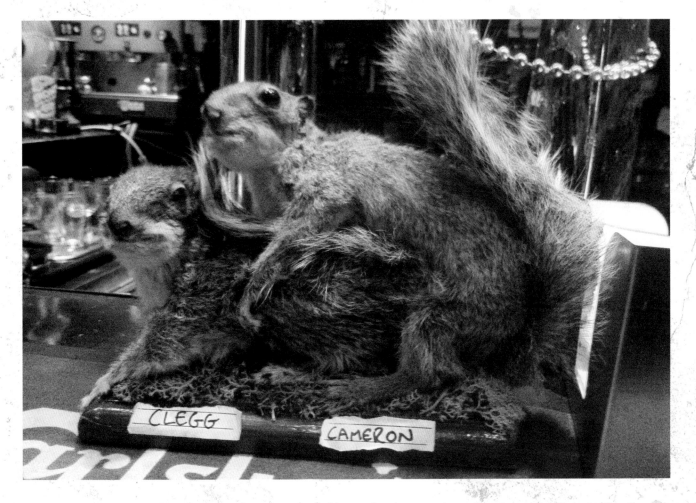

CLEGG CAMERON

I hope they're wearing a ConDem, The Nelson, Southwark

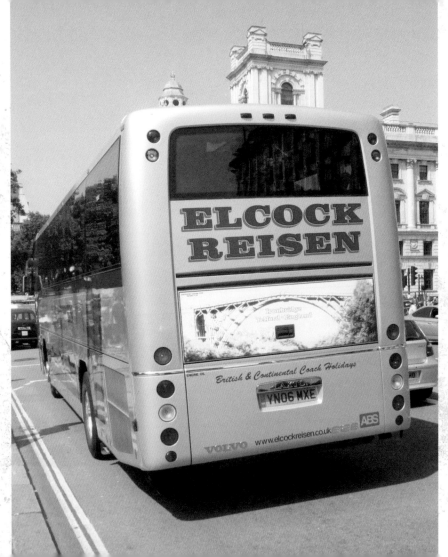

Erection coach, Parliament Square

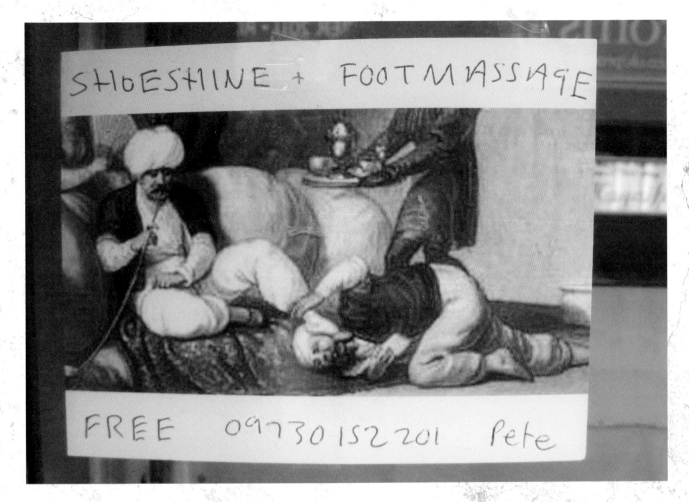

Foot fetishist's bizarre window card, Westbourne Park

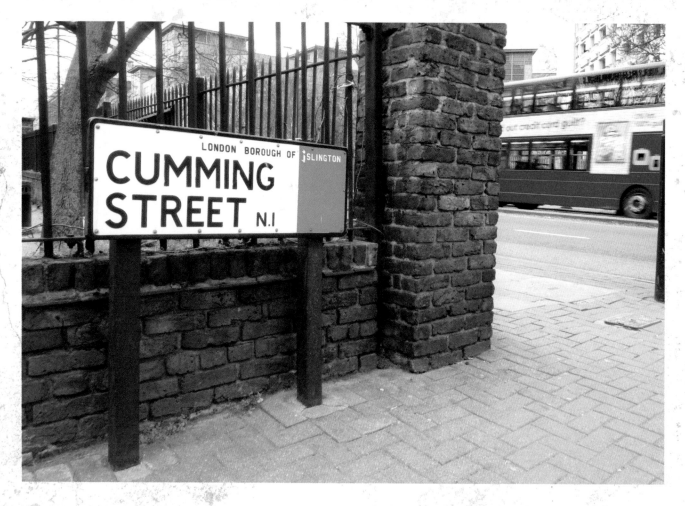

Watch your step, Islington

Fog Generating Security Equipment

The fog equipment will make it impossible to see after illegal entry. Tesco cannot accept any responsibility for any injuries caused by illegal entry.

not

Bum Confusion, Peckham Tesco

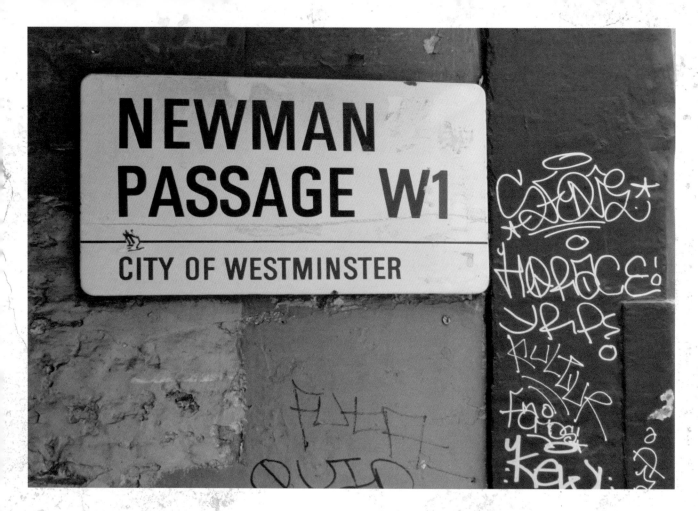

Colonic irrigation, Fitzrovia

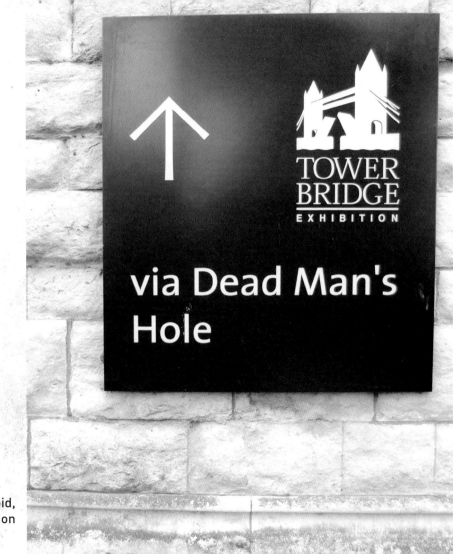

↑

TOWER
BRIDGE
EXHIBITION

via Dead Man's
Hole

A route to avoid,
The Tower of London

Genital specialist, Clerkenwell

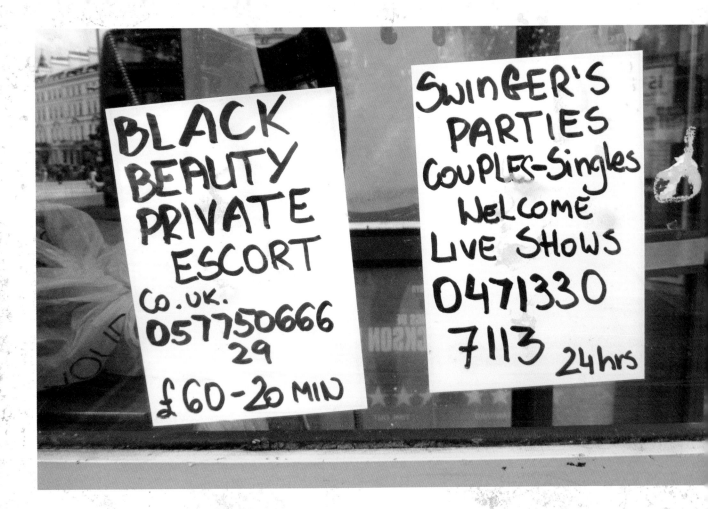

That poor horse's career has taken a nose-dive, South Kensington

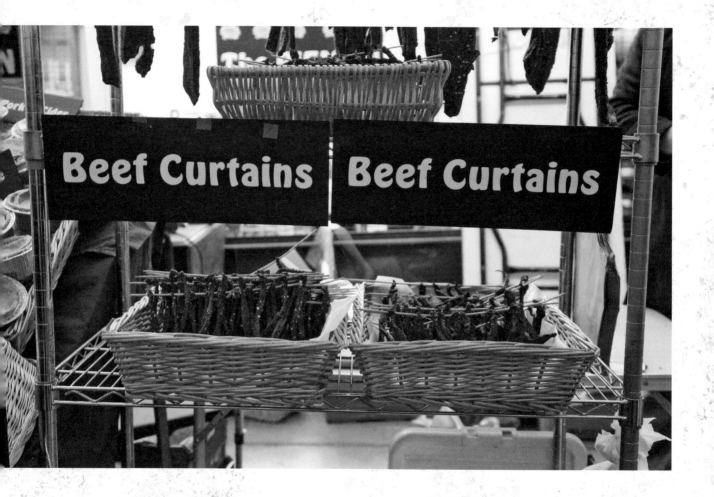

Interesting biltong marketing, Borough Market

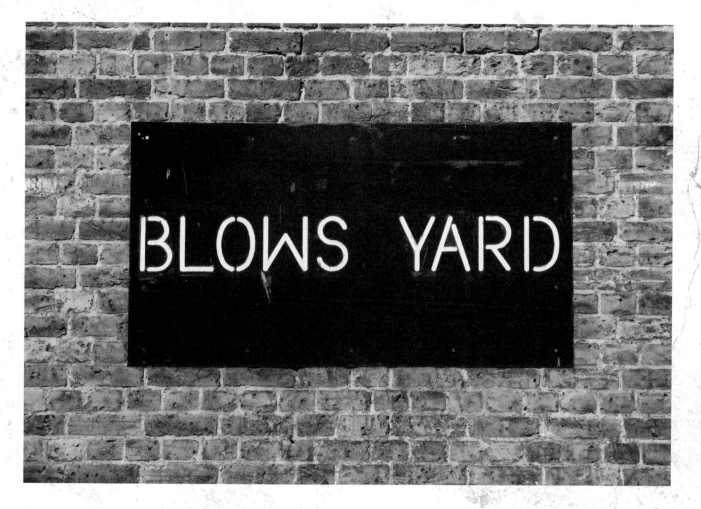

Winchester Walk

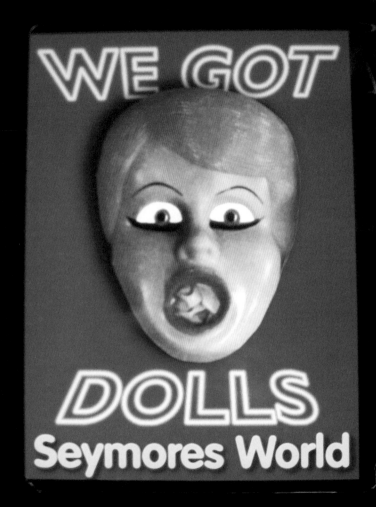

We got scared,
Walkers Court, Soho

In need of relief, Westminster

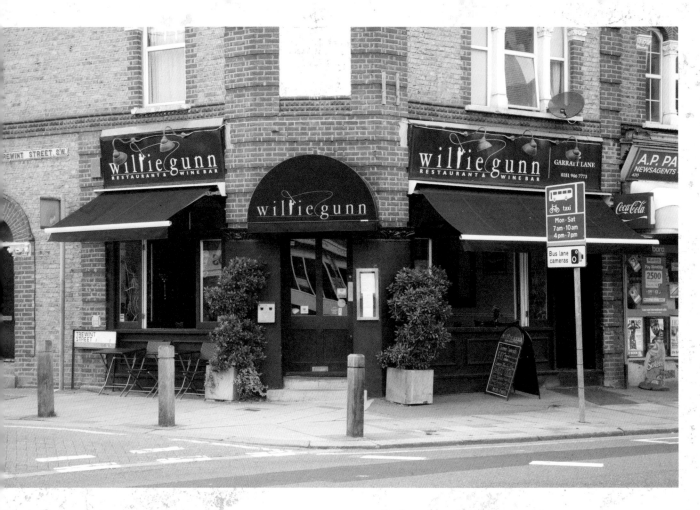

Bang, bang, Earlsfield

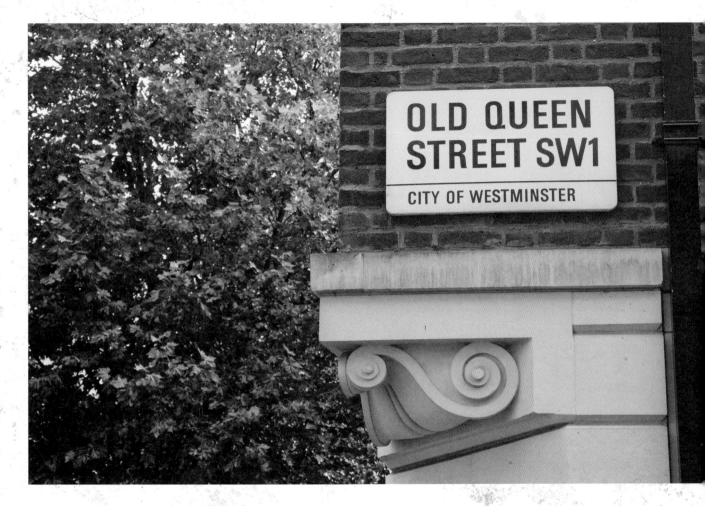

Normally found in Soho, Westminster

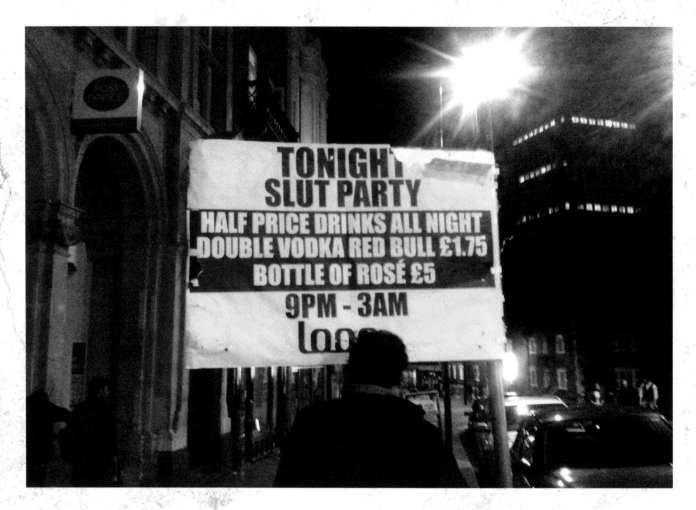

Only in Croydon, Croydon

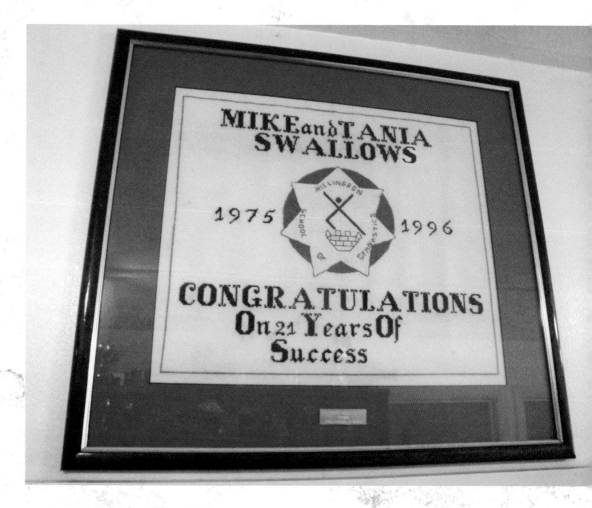

Tania knows the secret to a long-lasting marriage, South Ruislip

Pavement penis, Charing Cross

Wall tits, Tower Hamlets

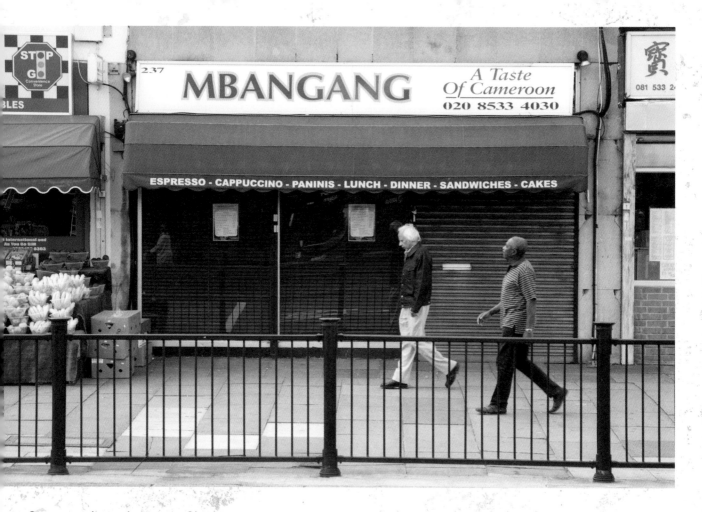

Group sex is on the menu, Clapton

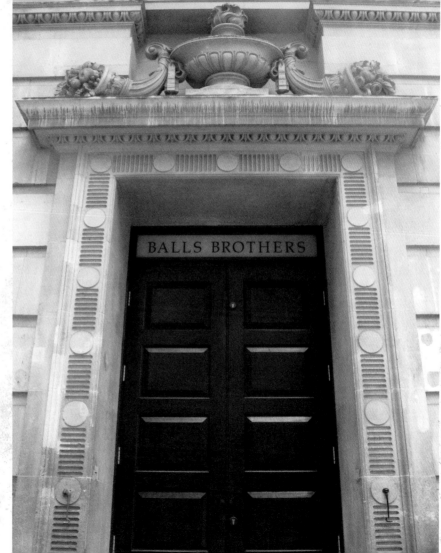

The secret brotherhood of the
testes, Lime Street, City of London

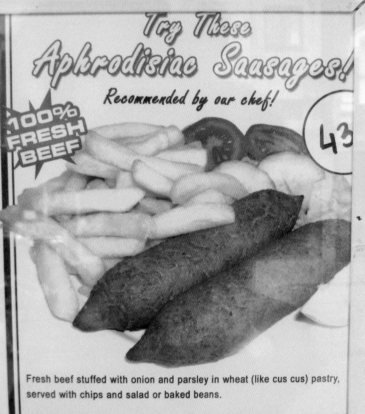

Try These Aphrodisiac Sausages!

Recommended by our chef!

100% FRESH BEEF

43

Fresh beef stuffed with onion and parsley in wheat (like cus cus) pastry, served with chips and salad or baked beans.

It's only recently that people in the UK are getting the taste of these origi... Pastry sausages. Originating from the island of Cyprus it takes a lot of ski... and time to produce.

Natives of Cyprus love eating these sausages because as well as being ve... tasty and good for your health they are also known to be Aphrodisiacs!

So Try Some Today!!

Chef's beefy love sausage,
Walthamstow

Keep an eye on the staff, Canning Town

Hi Guys, I'm a sexy single lady who works as a nurse and I'm looking for some no strings fun with guys of all ages in the area. Can meet at either my place or yours between shifts. If you're interested call or text me on 09774 471 913

Moonlighting nurse, Peckham

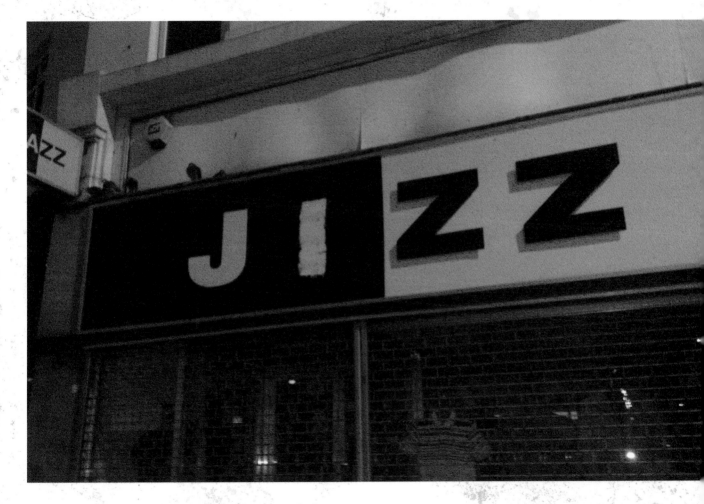

Spunky sign, Beckenham

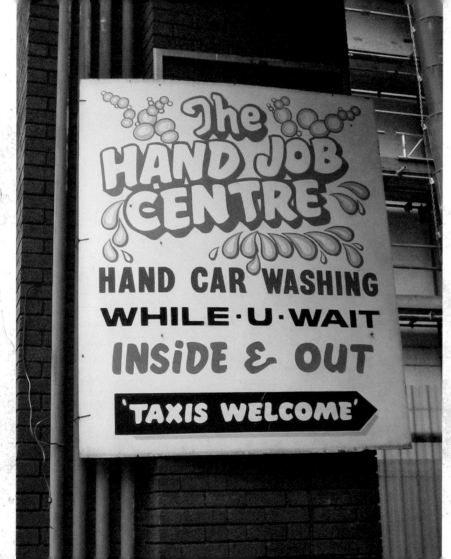

The HAND JOB CENTRE

HAND CAR WASHING
WHILE·U·WAIT
INSIDE & OUT
'TAXIS WELCOME'

Apparently the finish
is incredible, Olympia

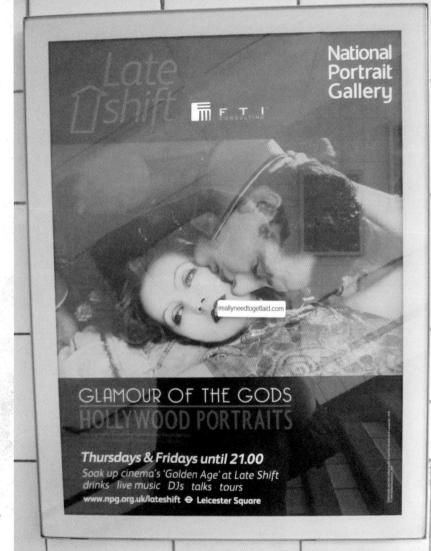

Stickered poster, Sloane Square

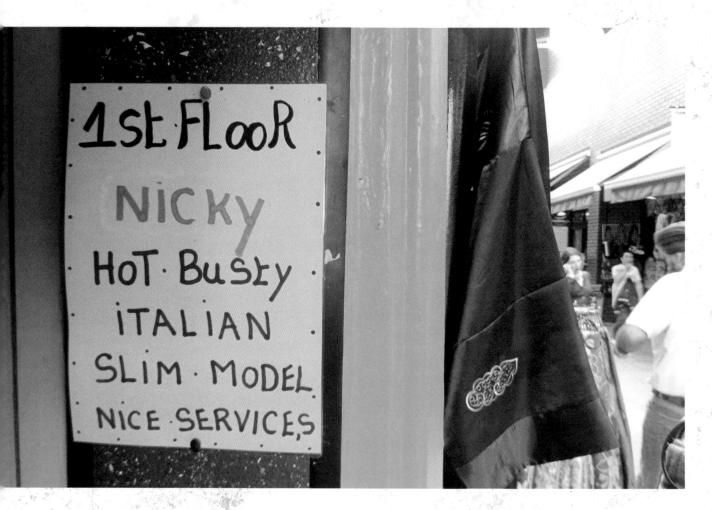

Nice services, Chinatown

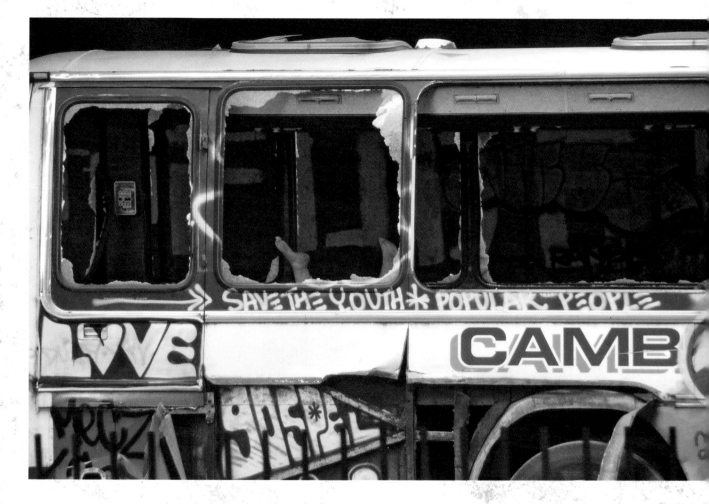

Coitus inabus, Stratford

Do you come here often?, Camden

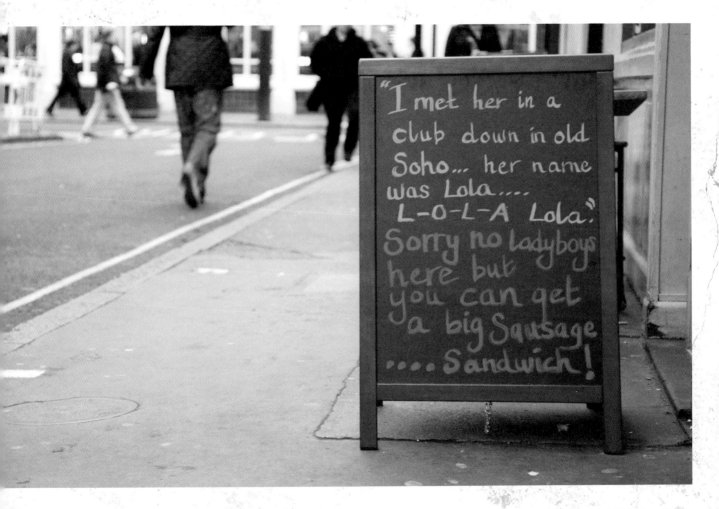

It has to be Soho, Soho

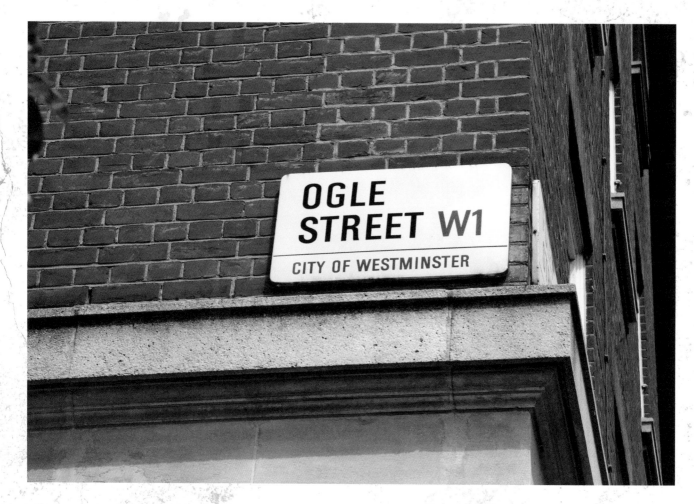

Don't mind if we do, Fitzrovia

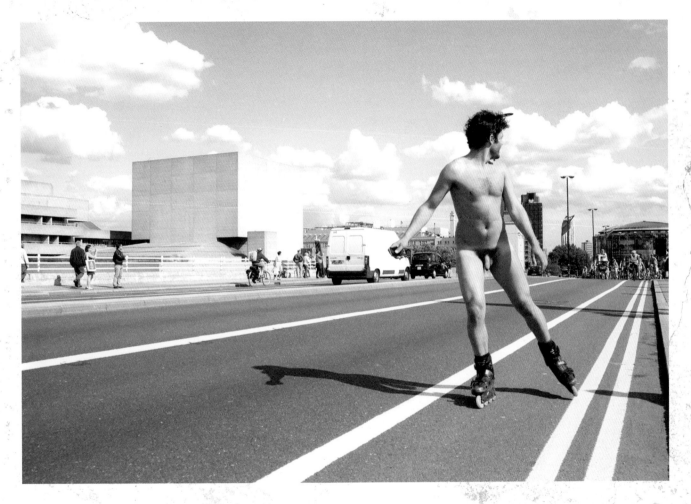

Lone nude rollerblader being chased, Waterloo Bridge

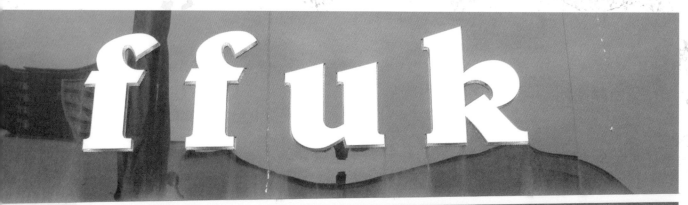

Not quite as stylish as FCUK, Finsbury Park

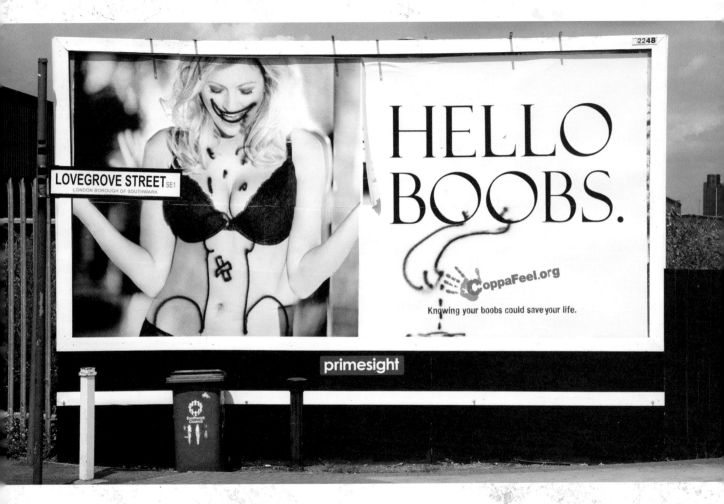

Adapted poster, Camberwell

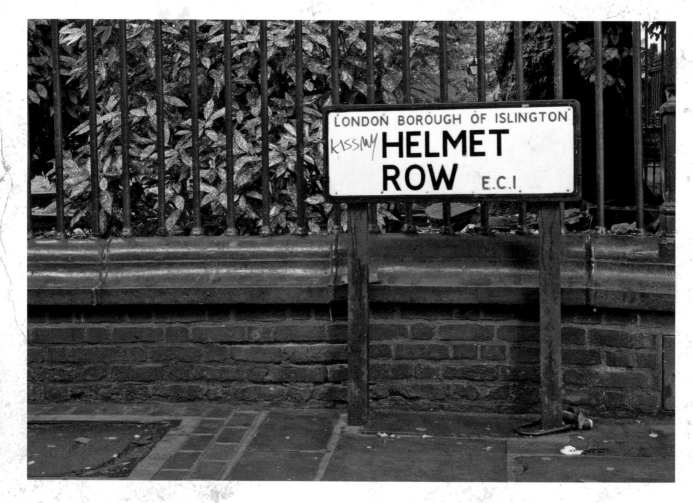

Romantic offer, Islington

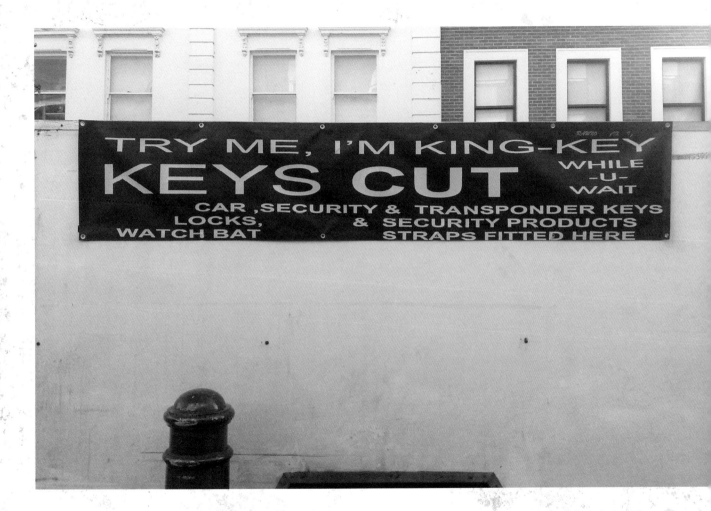

Subtlety, Kingston

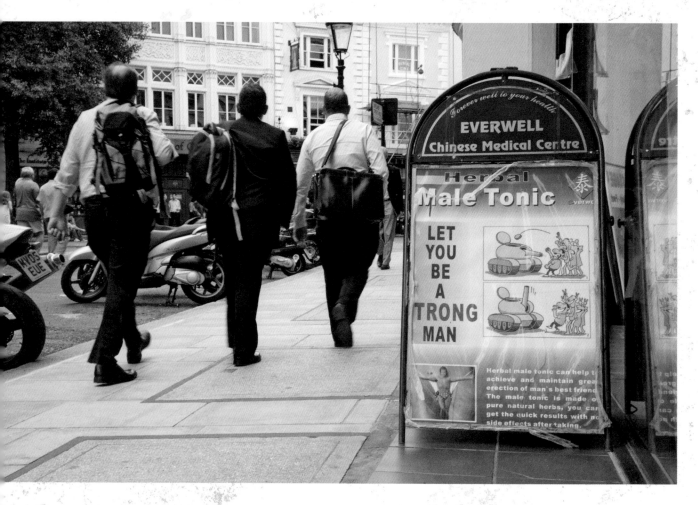

Erectile dysfunction poster with a Tiananmen Square motif, Charing Cross

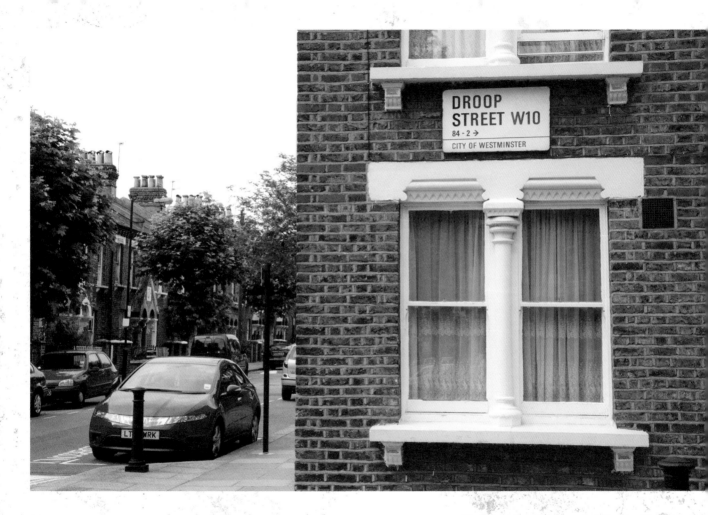

No laughing matter, Ladbroke Grove

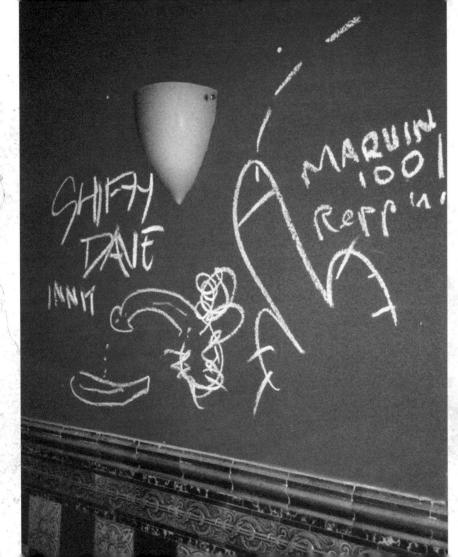

Shifty Dave strikes again,
New Cross

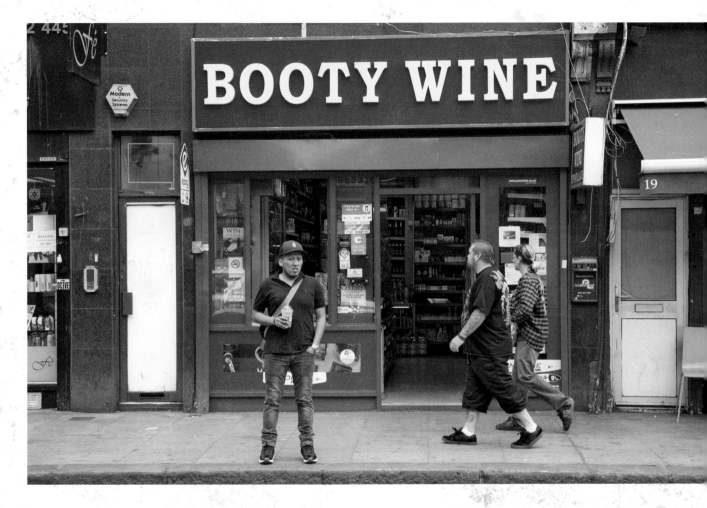

They must sit on the grapes, Camden

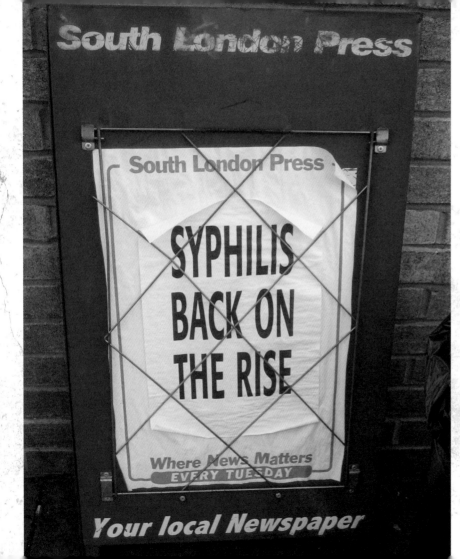

Bad news, Kennington

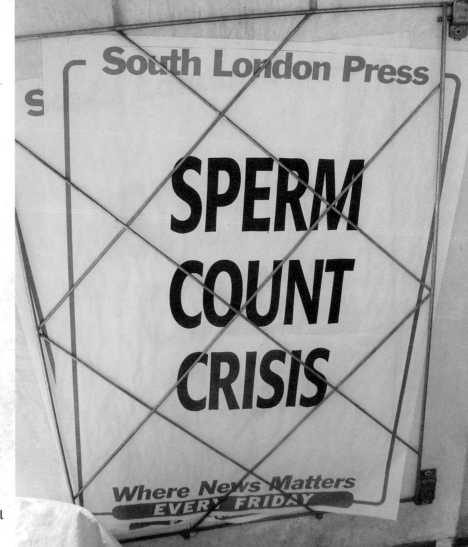

More bad news, Oval

PLEASE DO NOT
PARK IN FRONT
OF GATES

route

Ass Cleavage, Highbury and Islington

Rood London, City of London

SLICK WILLIES

12

Gloucester Road, Kensington

Gallic Knob Graffiti, Baker Street

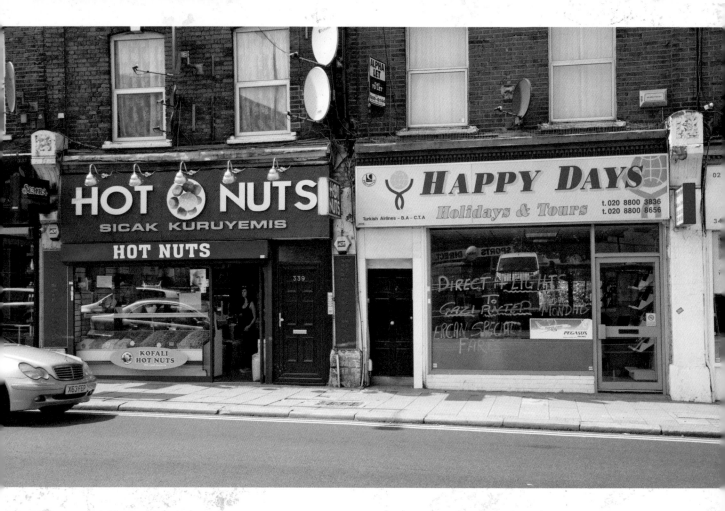

What a pair, Haringey

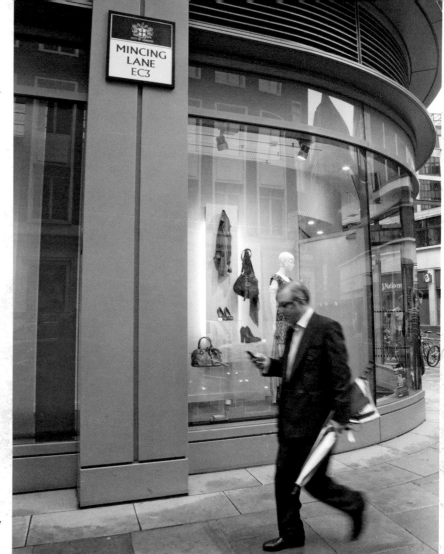

No comment, The City

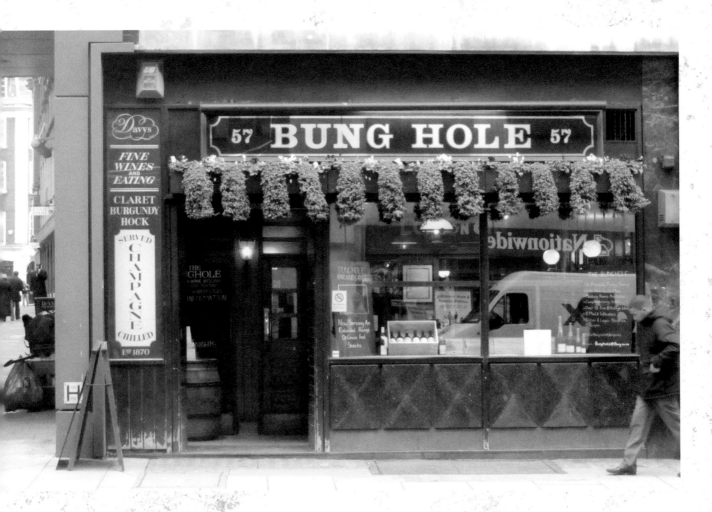

Nice pub, bad name, Holborn

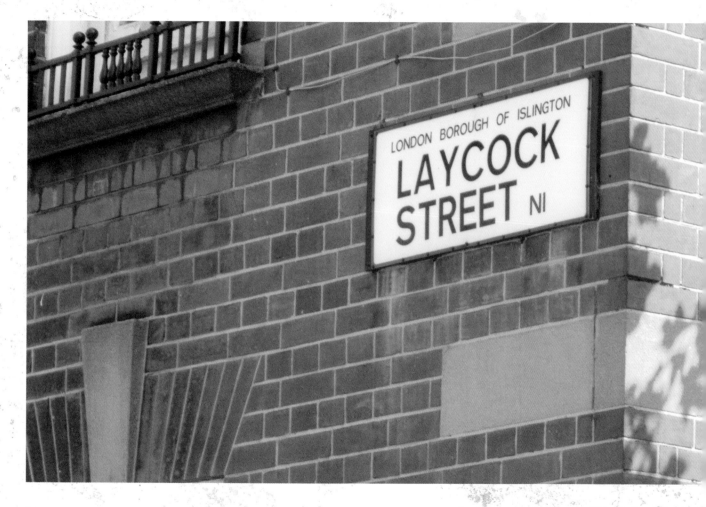

Correct use of an adjective, Islington

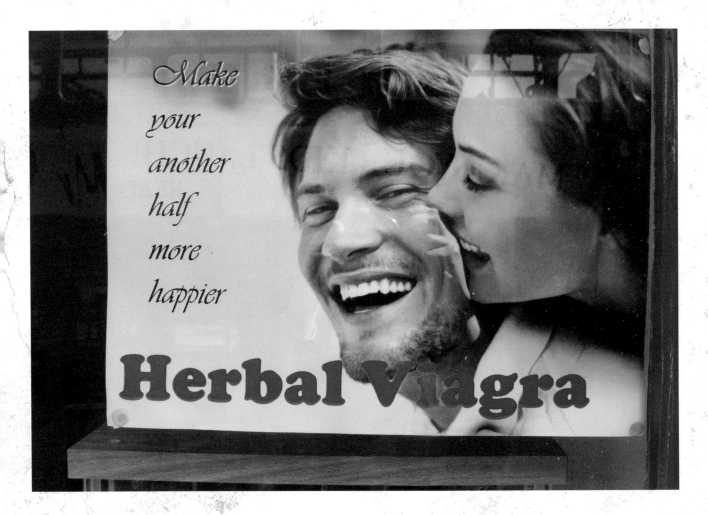

Odd poster, Shaftesbury Avenue

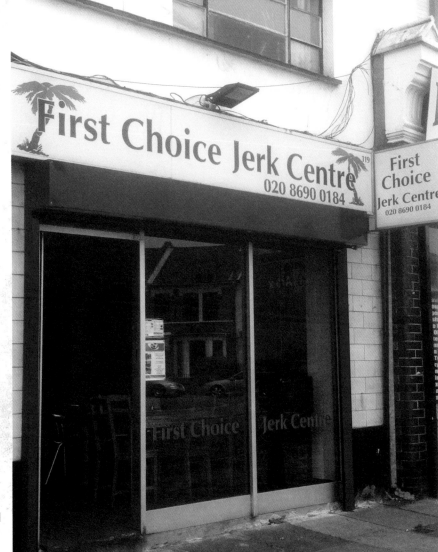

For the discerning onanist, Catford

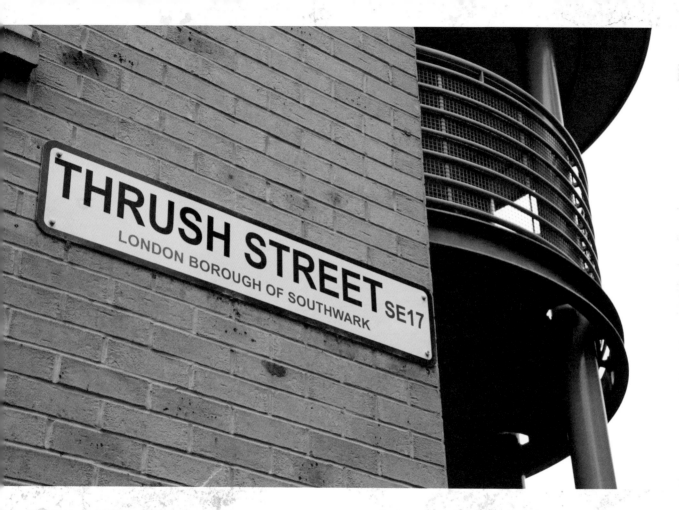

Don't even go there, Kennington

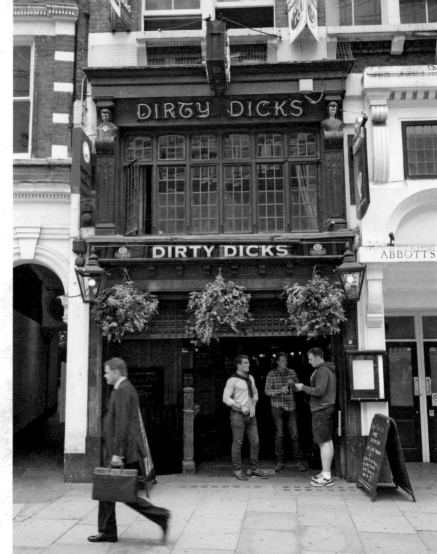

Personal hygiene issues,
Liverpool Street

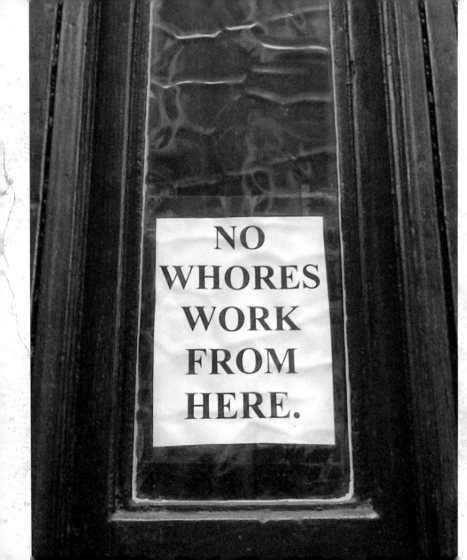

Good to know,
Duke of Wellington pub, Soho

DO NOT REMOVE

SOMEONE IS DEFECATING IN THIS CAR SPACE

WE HAVE IDENTIFIED THEM ON THE CCTV FOOTAGE

IT IS DISGUSTING AND NOT WHAT ANYONE SHOULD HAVE TO CLEAR UP FOR SOMEONE ELSE

IF YOU KNOW WHO IS DOING IT – PLEASE GET THEM TO STOP

IF IT IS YOU WHO IS DOING IT – **STOP RIGHT NOW**

Shit situation, Shad Thames

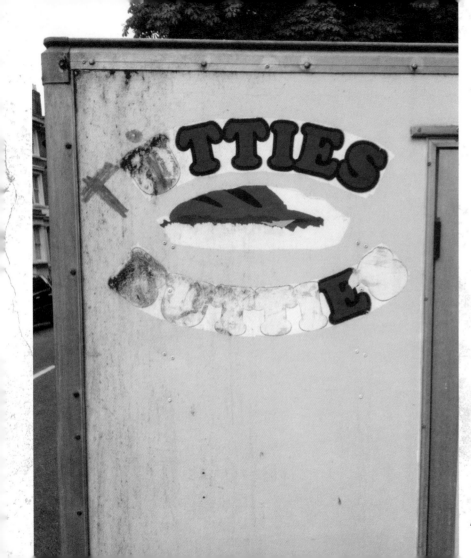

Adapted van, Notting Hill

Pearl necklace, Kings Cross

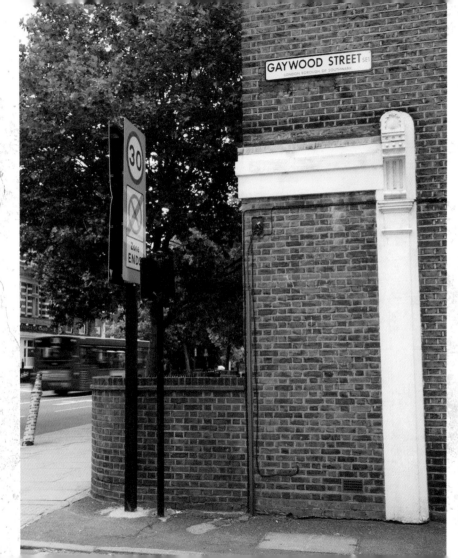

Fun place to live, Southwark

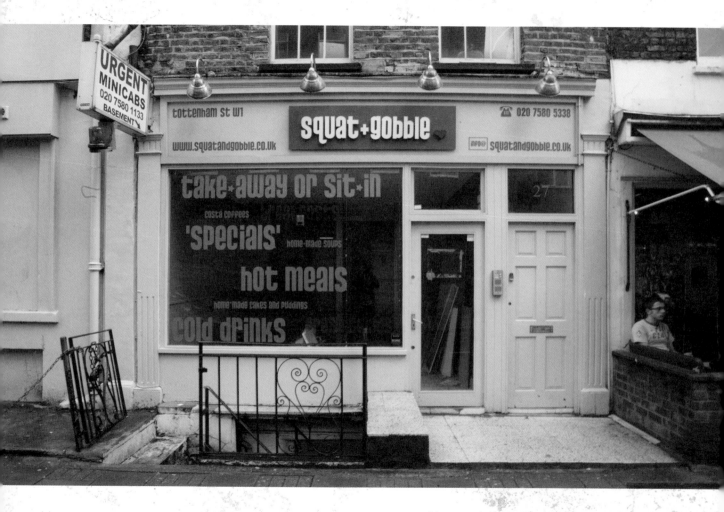

Unsurprisingly Closed Restaurant, Fitzrovia

But is it art?, Shad Thames

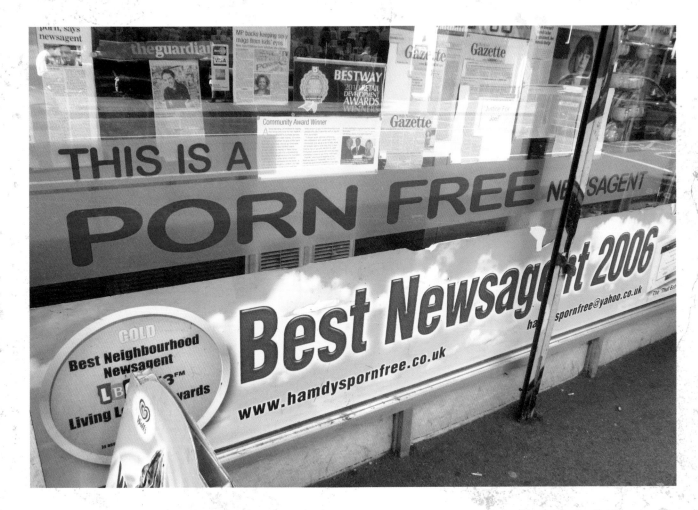

Spoilsports, Stoke Newington

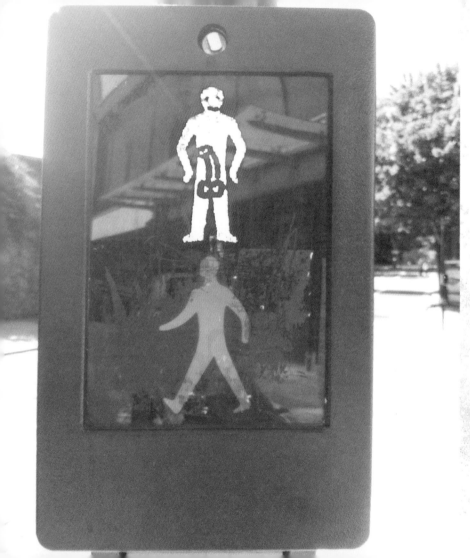

Stop Cock, Richmond

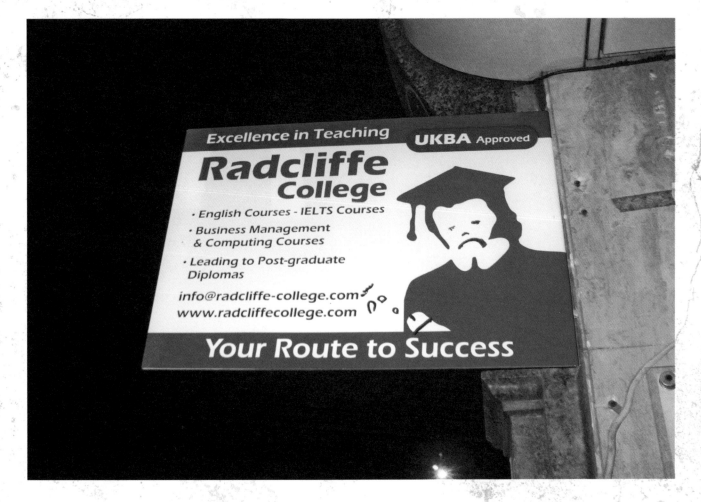

Dirty Teacher, Oxford Street

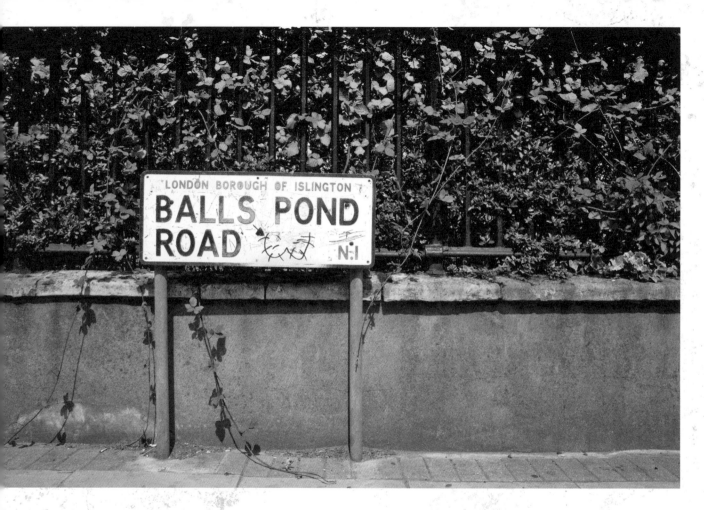

Fancy a dip?, Dalston

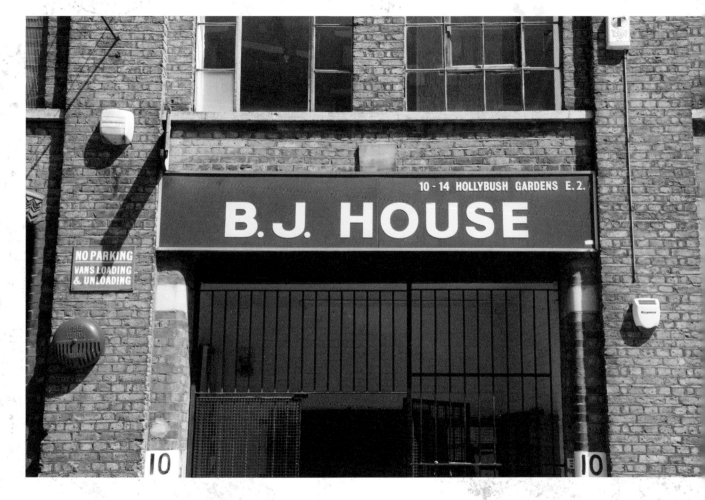

House of oral pleasures, Hollybush Gardens, Bethnal Green

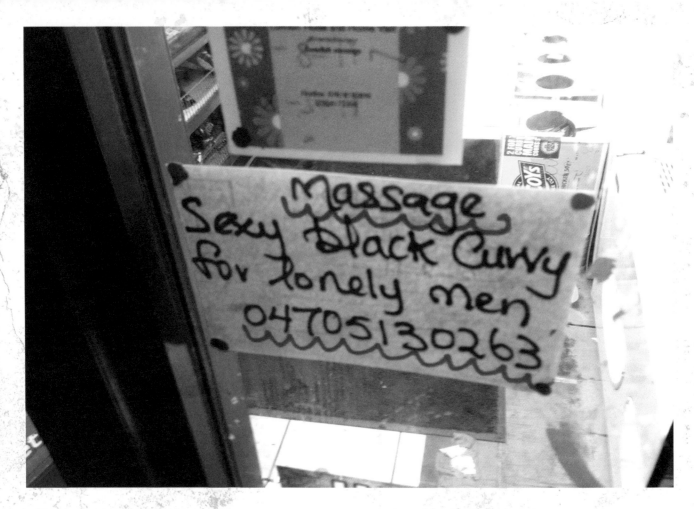

Pity masseuse, Clapham Common

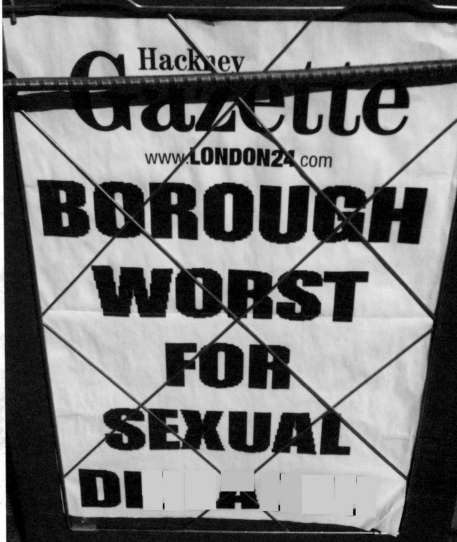

The best, and worst, place to get laid in London, Hackney

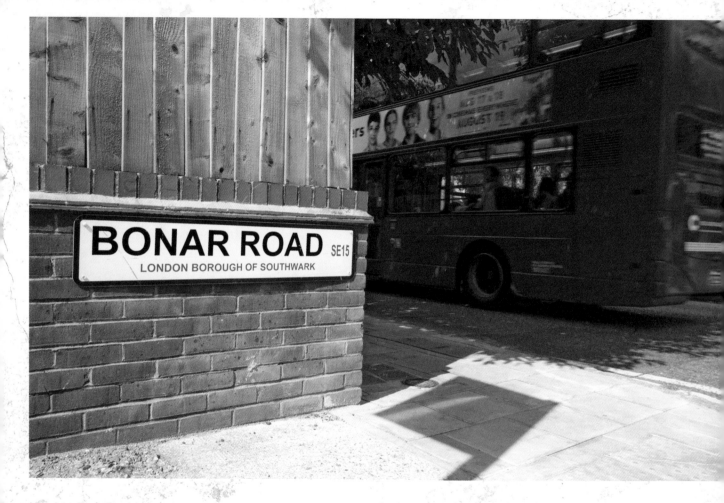

Hard to find, Peckham

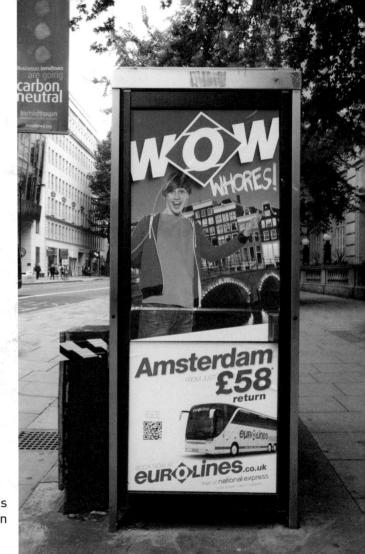

Justin Bieber discovers the delights
of Amsterdam, Holborn

Knob Lothario, Grey Eagle Street

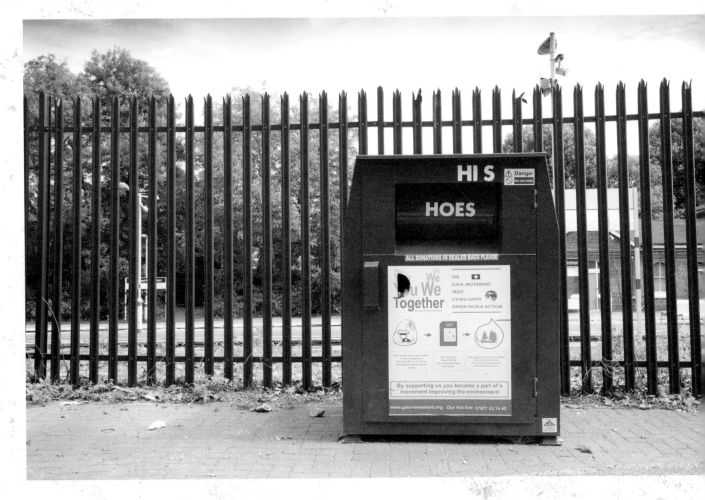

Storage facility for pimps, Wandsworth Common

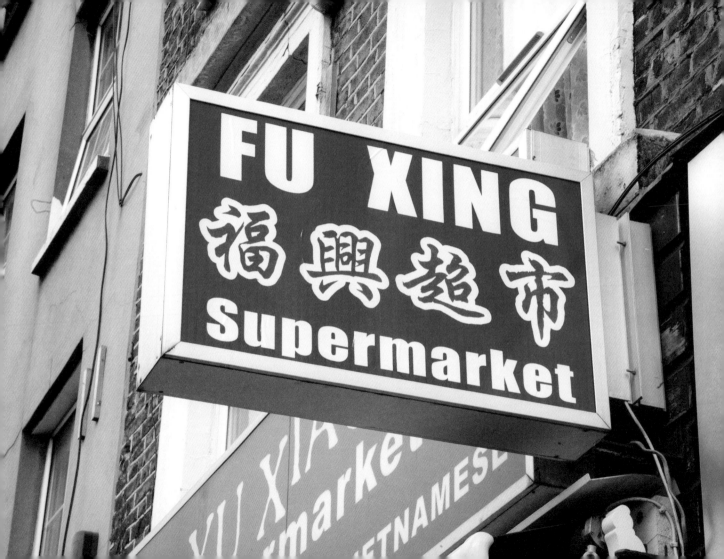

ACKNOWLEDGEMENTS

In no particular order I'd like to thank all my patient friends and family, Malcolm Croft, Katie Cowan and Harri O'Neill at Anova and everyone who has spotted something and sent a picture to the shitlondon.co.uk blog.

CONTRIBUTING PHOTOGRAPHERS

Mat Aldhouse, Daniel Alexander, Susan Always, Paul Bunnet, Bruce Croxford, Chrissie Dalziel, Flash Eroon, Jessica Good, Clare Hill, Charlotte Jewell, James Kirkwood, Carrie Lloyd, Ed Lomas, Liv Murton, Mary Paterson, Luca Pedrazzi, Ben Topiman, Sam Twiddy, Fay Warner, Tim Wilderspin.

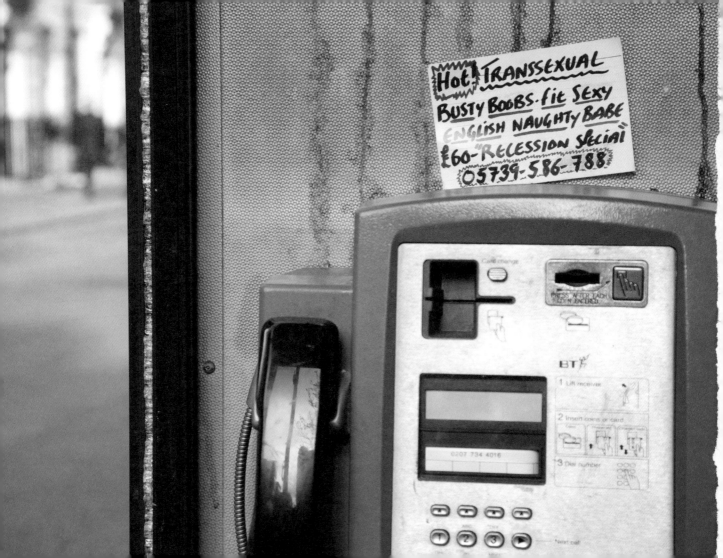